CONSTRUCTS

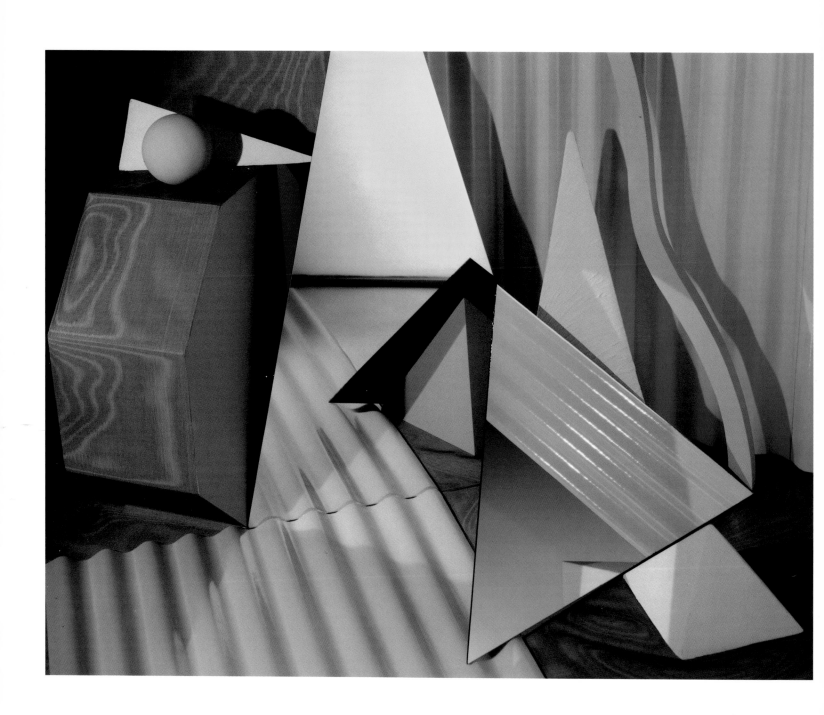

Construct NYC-17, 1984

CONSTRUCTS

Photographs by Barbara Kasten

Essay by Estelle Jussim

A Polaroid Book

New York Graphic Society Books • Little, Brown and Company • Boston

POEMS

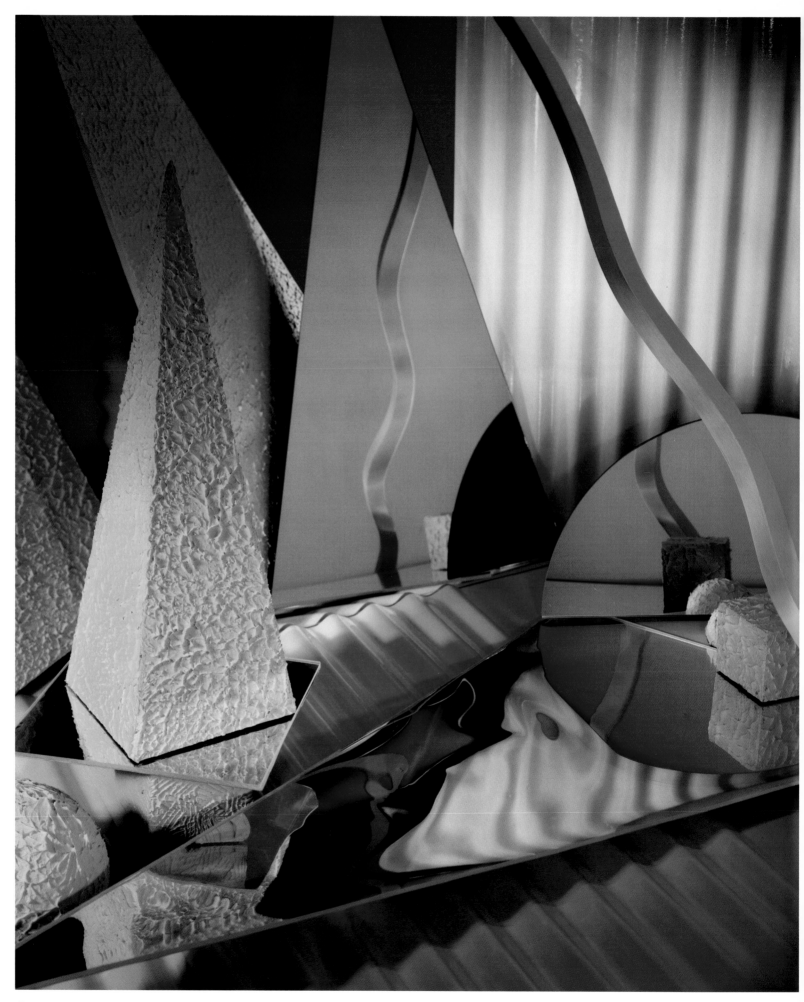

Construct XXX-XXIX, Diptych, 1984

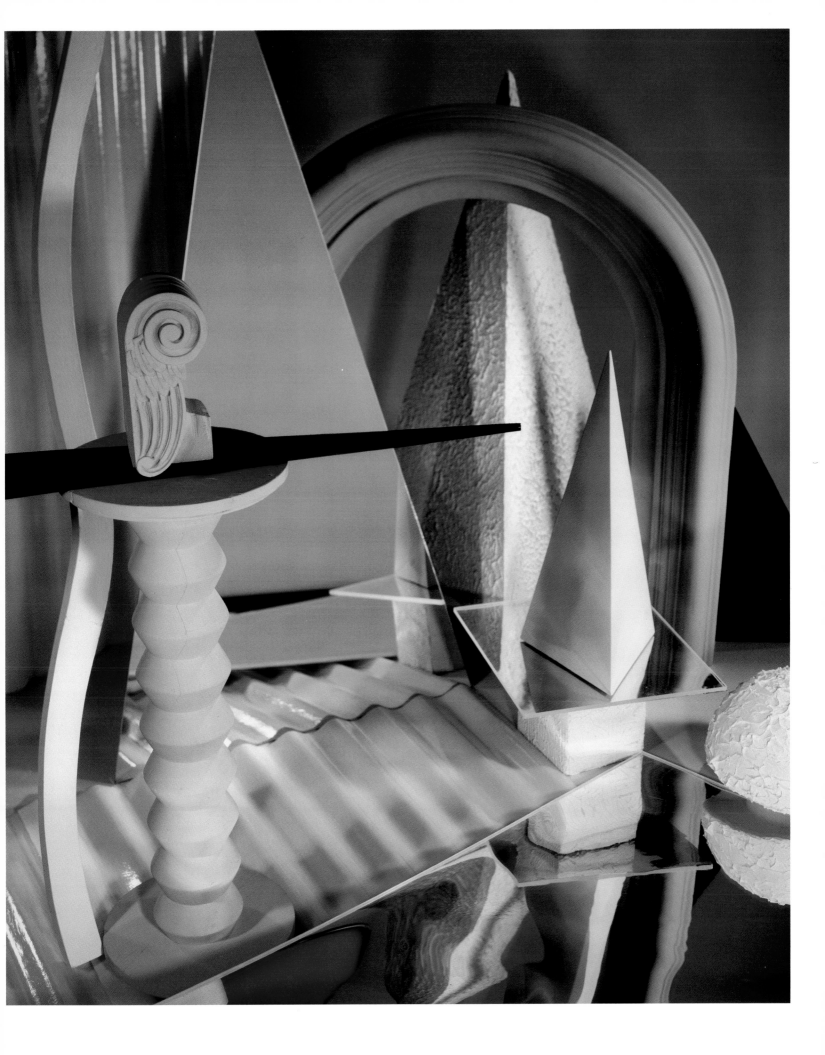

A MAP OF EUROPE

Derek Walcott

Like Leonardo's idea
Where landscapes open on a waterdrop
Or dragons crouch in stains,
My peeling wall, in the bright air,
Maps Europe with its veins.

On its limned window ledge
A beer can's gilded rim gleams like
Evening along a Canaletto lake
Or like that rock-bound, lion's hermitage
Where, in his cell of light, haggard Jerome
Prayed that Christ's kingdom come
To the far city.

The light creates its stillness. In its ring
Everything IS. A cracked coffee cup
A broken loaf, a dented urn become
More than themselves, their SELVES, as in Chardin,
Or in beer-bright Vermeer,
Not objects of our pity.

Within it is no lacrimae rerum,
No art. Only the gift
To see things as they are, halved by a darkness
From which they cannot shift.

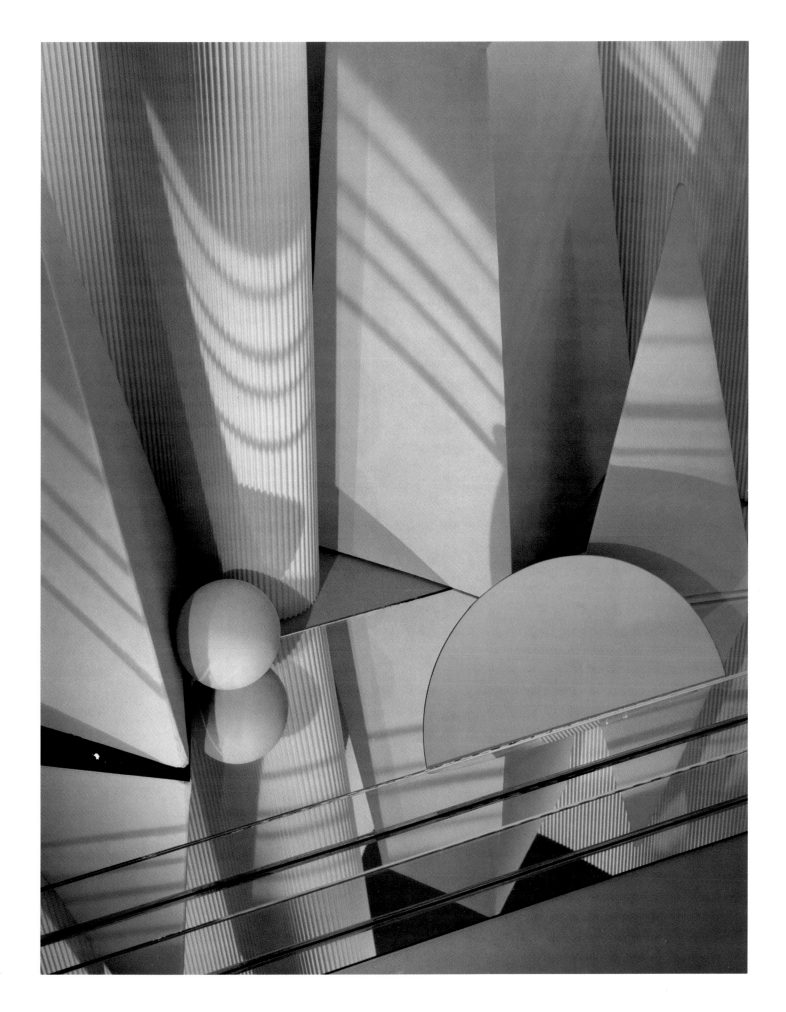

Construct NYC-11, 1983

ARS POETICA

Charles Wright

I like it back here

Under the green swatch of the pepper tree and the aloe vera.
I like it because the wind strips down the leaves without a word.
I like it because the wind repeats itself,
 and the leaves do.

I like it because I'm better here than I am there,

Surrounded by fetishes and figures of speech:
Dog's tooth and whale's tooth, my father's shoe, the dead weight
Of winter, the inarticulation of joy . . .

The spirits are everywhere.

And once I have them called down from the sky, and spinning and
 dancing in the palm of my hand,
What will it satisfy?
 I'll still have

The voices rising out of the ground,
The fallen star my blood feeds,
 this business I waste my heart on.

And nothing stops that.

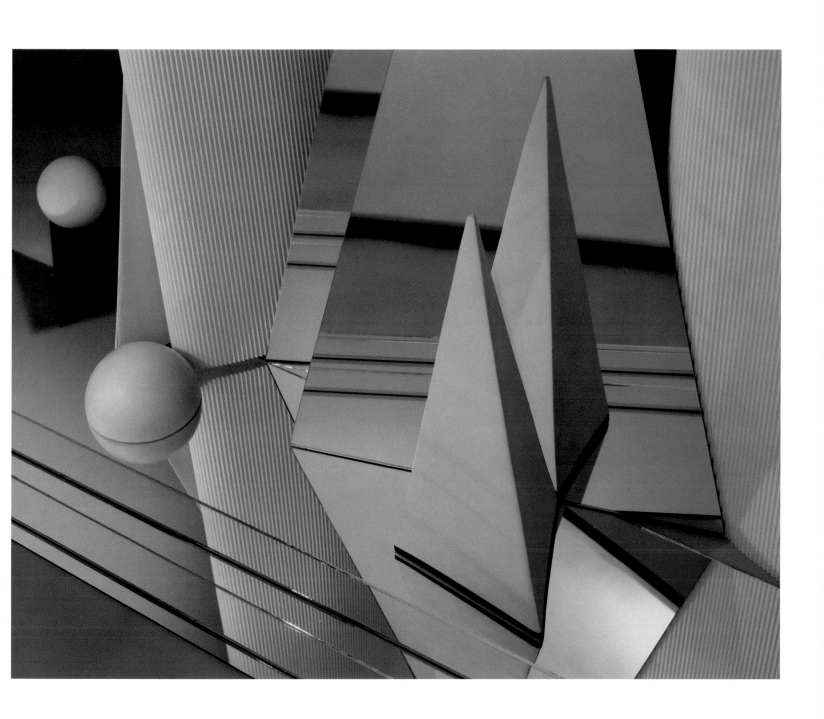

Construct NYC-10, 1983

WHITE TENT

Daniel Halpern

I pitched a tent in an open field
near what you thought were white birds
searching for seeds in an open field.
They were white tents pitched
here and there, and inside each a fire
burned with a single voice.
I built myself out of these white tents:
it doesn't matter what each voice said,
that I was many things—a stick
beating a sad dog, a woman standing
in any empty house, looking away,
a young boy running in place on a beach.
In my tent I pieced something together
and went back out into the field,
clothed in these many voices. The tents
turned back to white birds. White birds
took flight, lifted off the ground
their ultimate kindness and watched me
grow smaller and smaller, a hornet
without wings, walking back to the road
where you waited, looking after the birds
as they lifted, and disappeared.

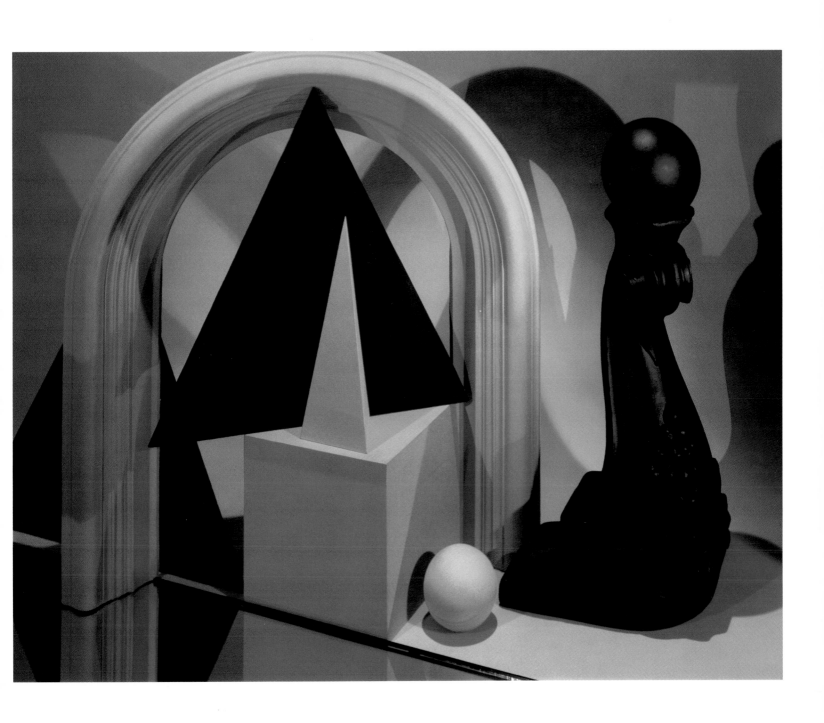

Construct NYC-14, 1984

CITIES & SIGNS

Italo Calvino

Translated from the Italian by William Weaver

You walk for days among trees and among stones. Rarely does the eye light on a thing, and then only when it has recognized that thing as the sign of another thing: a print in the sand indicates the tiger's passage; a marsh announces a vein of water; the hibiscus flower, the end of winter. All the rest is silent and interchangeable; trees and stones are only what they are.

Finally the journey leads to the city of Tamara. You penetrate it along streets thick with signboards jutting from the walls. The eye does not see things but images of things that mean other things: pincers point out the tooth-drawer's house; a tankard, the tavern; halberds, the barracks; scales, the grocer's. Statues and shields depict lions, dolphins, towers, stars: a sign that something—who knows what?—has as its sign a lion or a dolphin or a tower or a star. Other signals warn of what is forbidden in a given place (to enter the alley with wagons, to urinate behind the kiosk, to fish with your pole from the bridge) and what is allowed (watering zebras, playing bowls, burning relatives' corpses). From the doors of the temples the gods' statues are seen, each portrayed with his attributes—the cornucopia, the hourglass, the medusa—so that the worshiper can recognize them and address his prayers correctly. If a building has no signboard or figure, its very form and the position it occupies in the city's order suffice to indicate its function: the palace, the prison, the mint, the Pythagorean school, the brothel. The wares, too, which the vendors display on their stalls are valuable not in themselves but as signs of other things: the embroidered headband stands for elegance; the gilded palanquin, power; the volumes of Averroës, learning; the ankle bracelet, voluptuousness. Your gaze scans the streets as if they were written pages: the city says everything you must think, makes you repeat her discourse, and while you believe you are visiting Tamara you are only recording the names with which she defines herself and all her parts.

However the city may really be, beneath this thick coating of signs, whatever it may contain or conceal, you leave Tamara without having discovered it. Outside, the land stretches, empty, to the horizon; the sky opens, with speeding clouds. In the shape that chance and wind give the clouds, you are already intent on recognizing figures: a sailing ship, a hand, an elephant. . . .

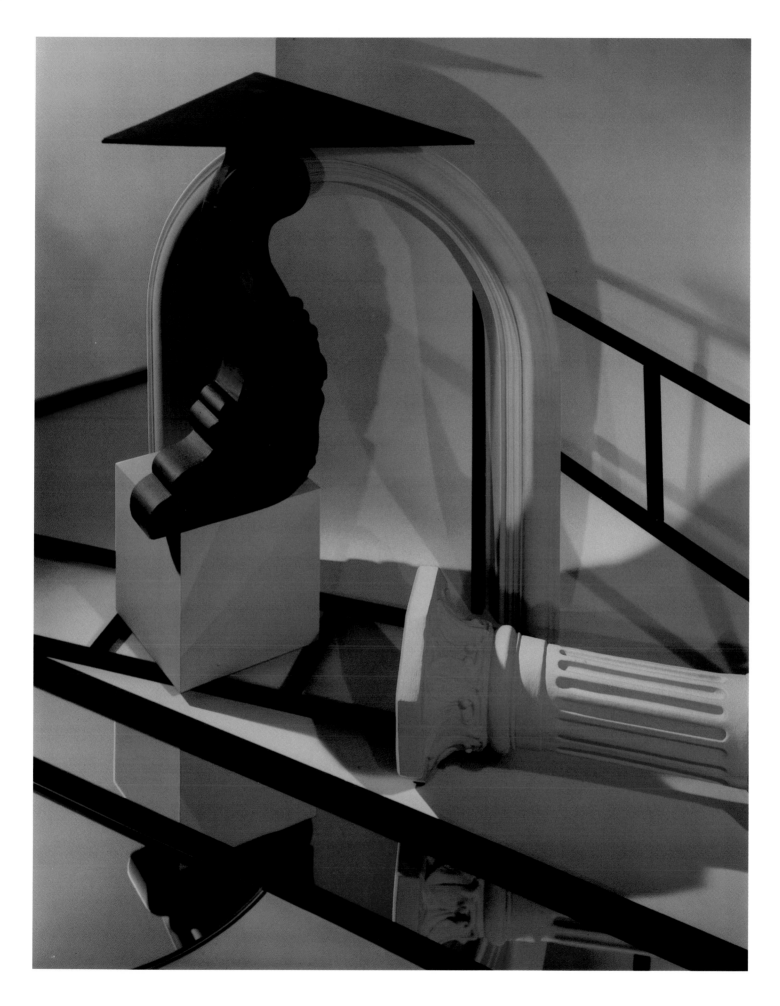

Construct NYC-12, 1984

THE MAP
Elizabeth Bishop

Land lies in water; it is shadowed green.
Shadows, or are they shallows, at its edges
showing the line of long sea-weeded ledges
where weeds hang to the simple blue from green.
Or does the land lean down to lift the sea from under,
drawing it unperturbed around itself?
Along the fine tan sandy shelf
is the land tugging at the sea from under?

The shadow of Newfoundland lies flat and still.
Labrador's yellow, where the moony Eskimo
has oiled it. We can stroke these lovely bays,
under a glass as if they were expected to blossom,
or as if to provide a clean cage for invisible fish.
The names of seashore towns run out to sea,
the names of cities cross the neighboring mountains
—the printer here experiencing the same excitement
as when emotion too far exceeds its cause.
These peninsulas take the water between thumb and finger
like women feeling for the smoothness of yard-goods.

Mapped waters are more quiet than the land is,
lending the land their waves' own conformation:
and Norway's hare runs south in agitation,
profiles investigate the sea, where land is.
Are they assigned, or can the countries pick their colors?
—What suits the character or the native waters best.
Topography displays no favorites; North's as near as West.
More delicate than the historians' are the map-makers' colors.

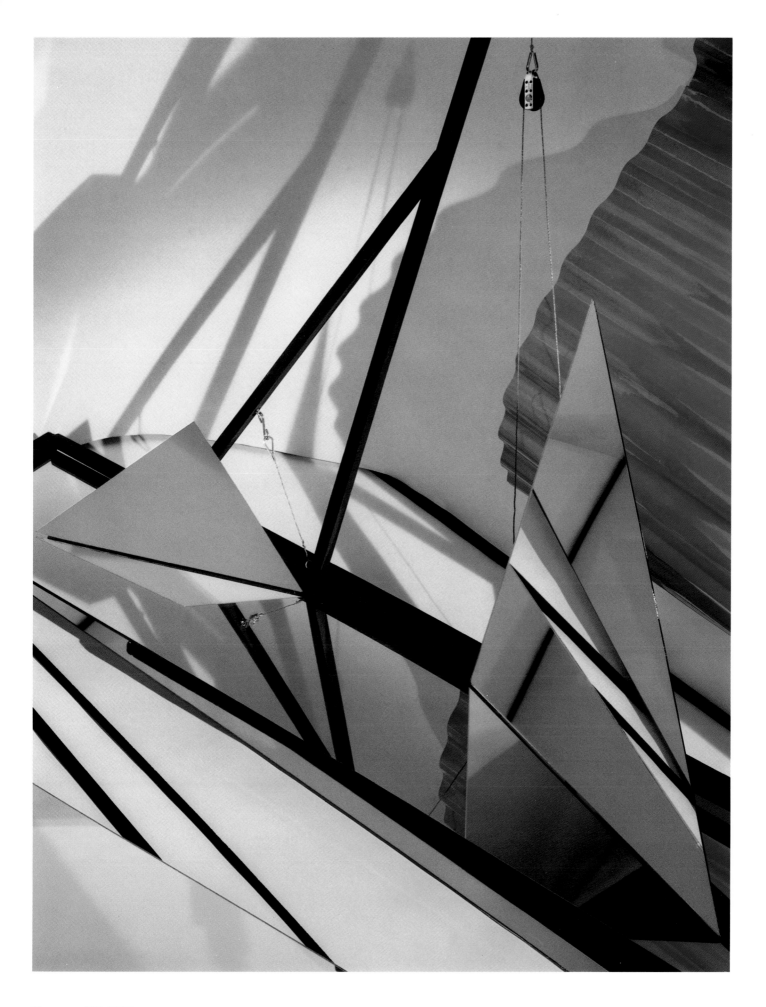

Construct XIV, 1982

ENCOUNTER

Czeslaw Milosz
Translated from the Polish by the poet and Lillian Vallee

We were riding through frozen fields in a wagon at dawn.
A red wing rose in the darkness.

And suddenly a hare ran across the road.
One of us pointed to it with his hand.

That was long ago. Today neither of them is alive,
Not the hare, nor the man who made the gesture.

O my love, where are they, where are they going
The flash of a hand, streak of movement, rustle of pebbles.
I ask not out of sorrow, but in wonder.

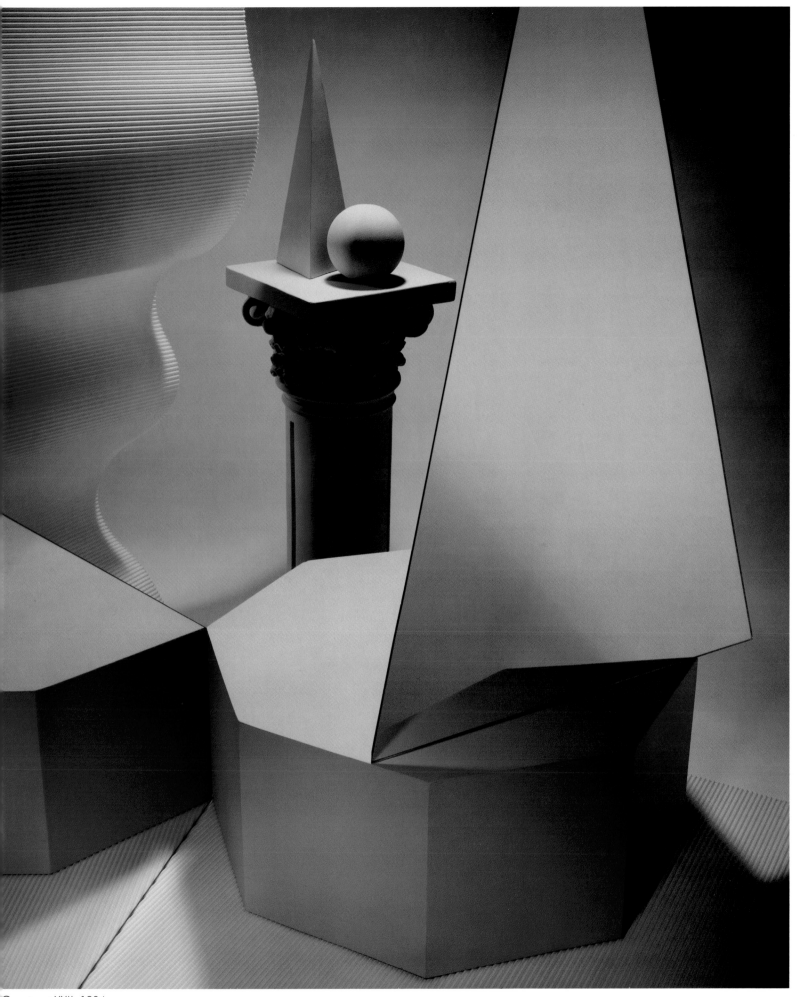

Construct XXII, 1984

MEDITATION AT LAGUNITAS

Robert Hass

All the new thinking is about loss.
In this it resembles all the old thinking.
The idea, for example, that each particular erases
the luminous clarity of a general idea. That the clown-
faced woodpecker probing the dead sculpted trunk
of that black birch is, by his presence,
some tragic falling off from a first world
of undivided light. Or the other notion that,
because there is in this world no one thing
to which the bramble of *blackberry* corresponds,
a word is elegy to what it signifies.
We talked about it late last night and in the voice
of my friend, there was a thin wire of grief, a tone
almost querulous. After a while I understood that,
talking this way, everything dissolves: *justice,*
pine, hair, woman, you and *I.* There was a woman
I made love to and I remembered how, holding
her small shoulders in my hands sometimes,
I felt a violent wonder at her presence
like a thirst for salt, for my childhood river
with its island willows, silly music from the pleasure boat,
muddy places where we caught the little orange-silver fish
called *pumpkinseed.* It hardly had to do with her.
Longing, we say, because desire is full
of endless distances. I must have been the same to her.
But I remember so much, the way her hands dismantled bread,
the thing her father said that hurt her, what
she dreamed. There are moments when the body is as numinous
as words, days that are the good flesh continuing.
Such tenderness, those afternoons and evenings,
saying *blackberry, blackberry, blackberry.*

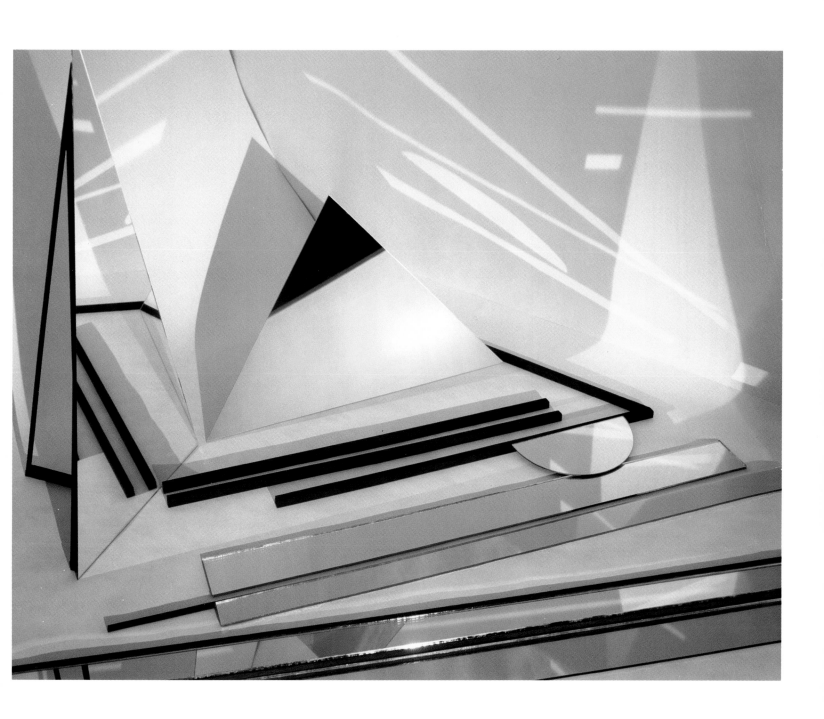

Construct LB/2, 1982

KEEPING THINGS WHOLE

Mark Strand

In a field
I am the absence
of field.
This is
always the case.
Wherever I am
I am what is missing.

When I walk
I part the air
and always
the air moves in
to fill the spaces
where my body's been.

We all have reasons
for moving.
I move
to keep things whole.

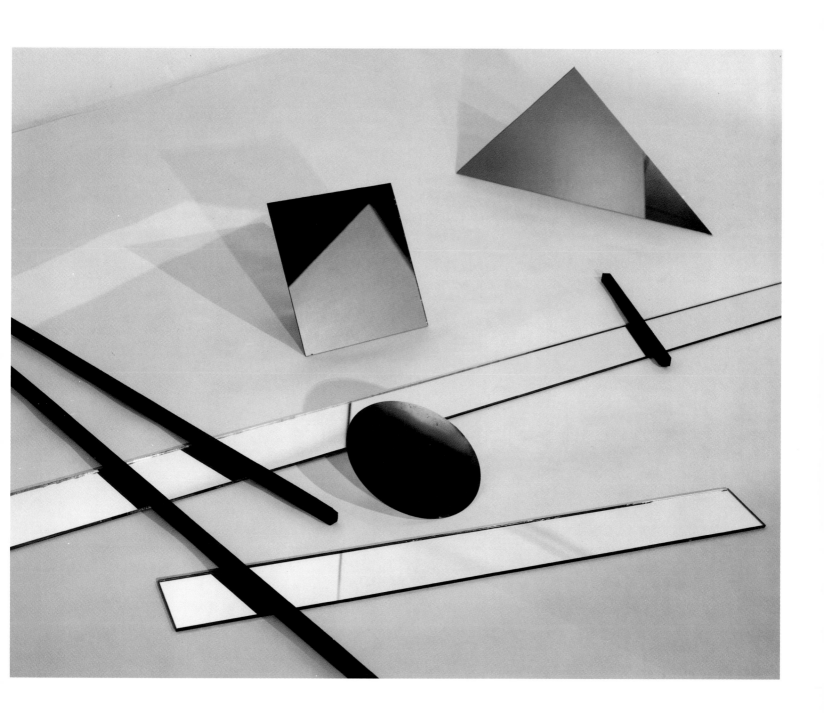

Construct V-A, 1980

SCAFFOLDING

Seamus Heaney

Masons, when they start upon a building,
Are careful to test out the scaffolding;

Make sure that planks won't slip at busy points,
Secure all ladders, tighten bolted joints.

And yet all this comes down when the job's done
Showing off walls of sure and solid stone.

So if, my dear, there sometimes seem to be
Old bridges breaking between you and me

Never fear. We may let the scaffolds fall
Confident that we have built our wall.

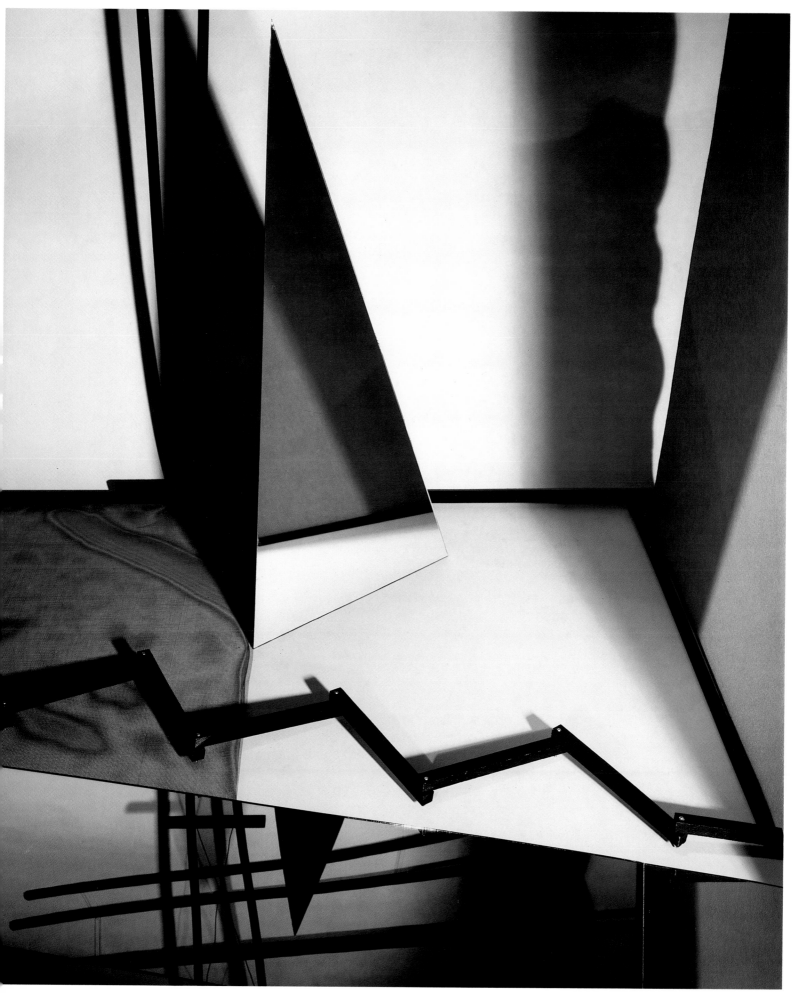

Construct PC/2B, 1981

SOUVENIR OF THE ANCIENT WORLD

Carlos Drummond de Andrade
Translated from the Portuguese by Mark Strand

Clara strolled in the garden with the children.
The sky was green over the grass,
the water was golden under the bridges,
other elements were blue and rose and orange,
a policeman smiled, bicycles passed,
a girl stepped onto the lawn to catch a bird,
the whole world—Germany, China—all was quiet around Clara.

The children looked at the sky: it was not forbidden.
Mouth, nose, eyes were open. There was no danger.
What Clara feared were the flu, the heat, the insects.
Clara feared missing the eleven o'clock trolley,
waiting for letters slow to arrive,
not always being able to wear a new dress. But she strolled in the
 garden, in the morning!
They had gardens, they had mornings in those days!

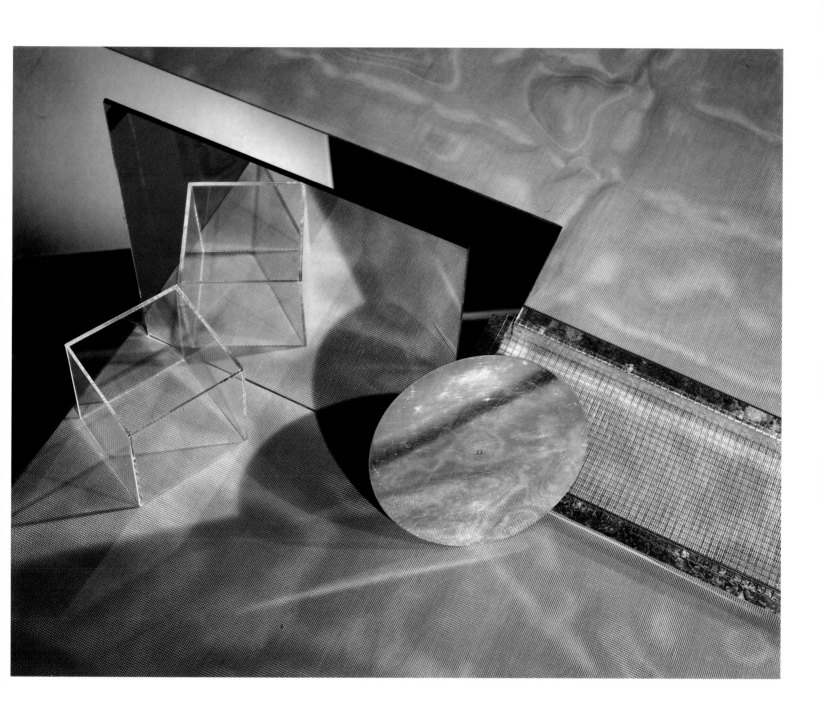

Construct III-D, 1980

OFFICER'S QUARTERS

John Hollander

This room is lit by winter

And this stove, giving heat and keeping what light it has within it,

Is yet doing an act of light, even to the corner of the room

Where Captain Consciousness sits at the bare table, writing by the light of his own hand

Outside in the northern sky, above the frozen canal, dark specks of duck

Undiscernible as bird, but flying away:

Inside, the bright images and hard-edged, in the warmth, the radiance.

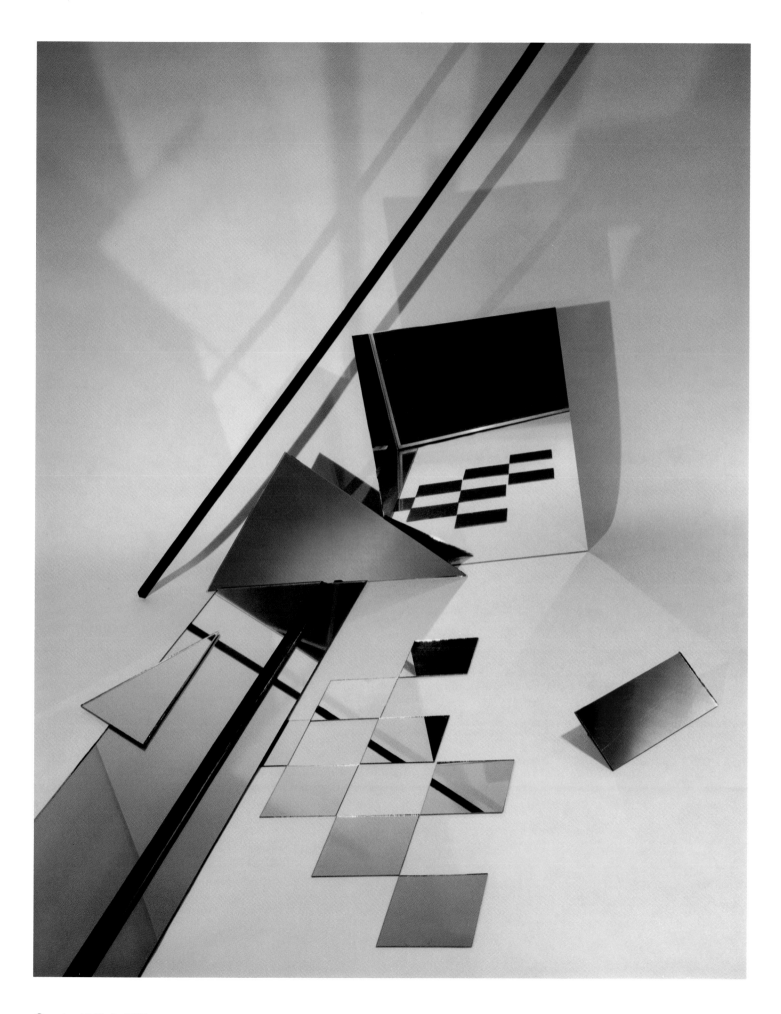

Construct VIII-A, 1981

ALL HALLOWS

Louise Glück

Even now this landscape is assembling.
The hills darken. The oxen
sleep in their blue yoke,
the fields having been
picked clean, the sheaves
bound evenly and piled at the roadside
among cinquefoil, as the toothed moon rises:

This is the barrenness
of harvest or pestilence.
And the wife leaning out the window
with her hand extended, as in payment,
and the seeds
distinct, gold, calling
Come here
Come here, little one

And the soul creeps out of the tree.

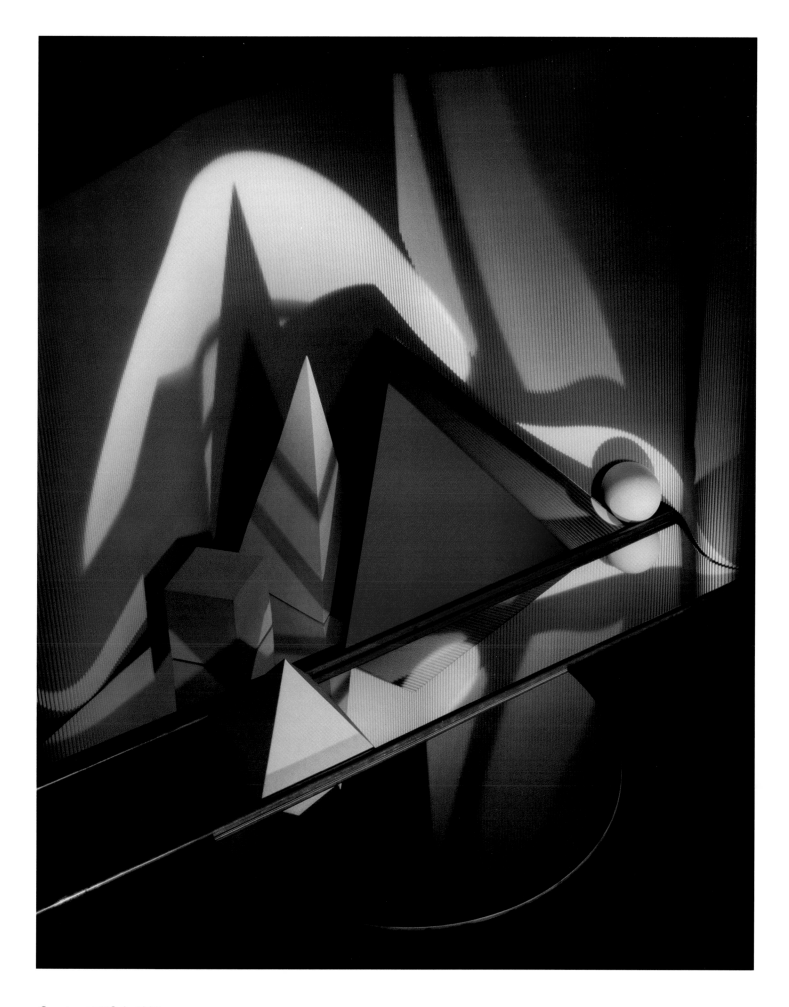

Construct NYC-9, 1983

A LETTER

Anthony Hecht

 I have been wondering
 What you are thinking about, and by now suppose
 It is certainly not me.
 But the crocus is up, and the lark, and the blundering
 Blood knows what it knows.
It talks to itself all night, like a sliding moonlit sea.

 Of course, it is talking of you.
 At dawn, where the ocean has netted its catch of lights,
 The sun plants one lithe foot
 On that spill of mirrors, but the blood goes worming through
 Its warm Arabian nights,
Naming your pounding name again in the dark heart-root.

 Who shall, of course, be nameless.
 Anyway, I should want you to know I have done my best,
 As I'm sure you have, too.
 Others are bound to us, the gentle and blameless
 Whose names are not confessed
In the ceaseless palaver. My dearest, the clear unquarried blue

 Of those depths is all but blinding.
 You may remember that once you brought my boys
 Two little woolly birds.
 Yesterday the older one asked for you upon finding
 Your thrush among his toys.
And the tides welled about me, and I could find no words.

 There is not much else to tell.
 One tries one's best to continue as before,
 Doing some little good.
 But I would have you know that all is not well
 With a man dead set to ignore
The endless repetitions of his own murmurous blood.

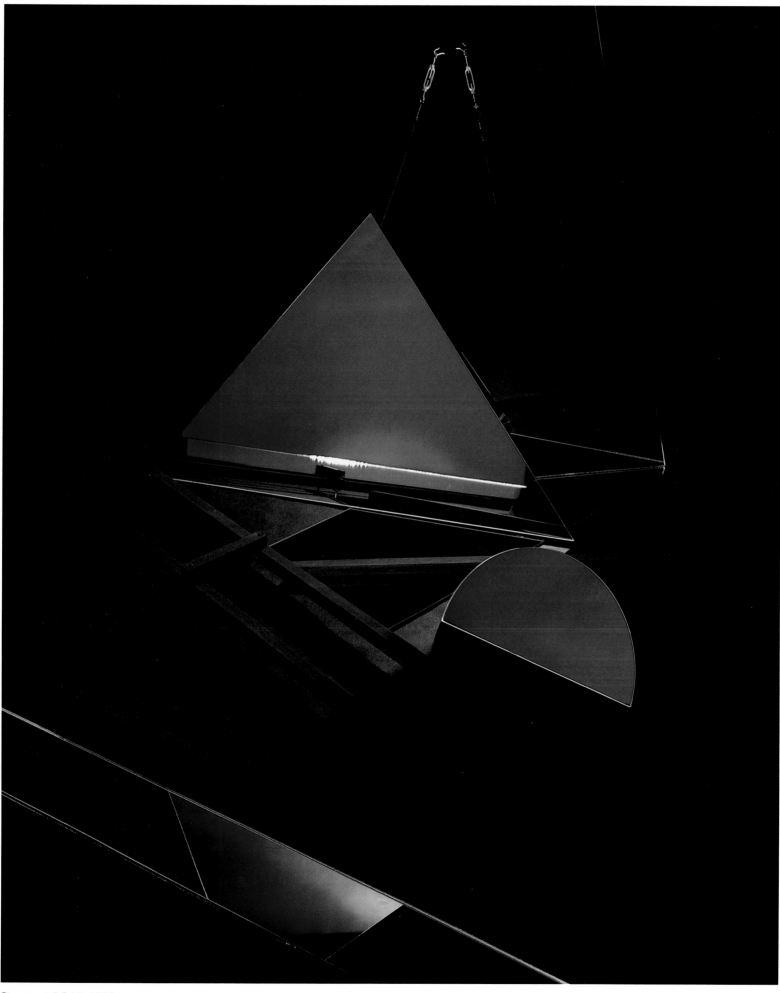

Construct PC-VI, 1982

THE OPTICAL FANTASIES OF BARBARA KASTEN

Estelle Jussim

The rhythmic law of constructive counterpoint, contained in a creative
masterpiece, sets into motion life itself, through a rhythm displayed between
harmonies and the contrasts of color and form. Wassily Kandinsky

They are theater, sculpture, painting, light play – all masquerading as photographs. They are obsessively perfect, complex, imaginative yet completely controlled. They interweave colors saturated with light and light creating color on mirrored scaffoldings – illusory, sometimes perverse, unpredictable, requiring a visual response as intense as her own, demanding a clearing of the spectator's mind prior to surrender to her majestic polyphonies; yet they are instantly pleasurable. They are everything Wassily Kandinsky swore was the science of art and László Moholy-Nagy speculated was the future of color photography. They are marvelous, visually stunning ordered universes tinged with a brooding metaphysic that claims mystery and fascination as ultimate goals.

Barbara Kasten has mastered many media, in the true tradition of the Bauhaus ideology that viewed every material and each medium as artistically potent. She fabricates, or has constructed for her, all the objects in her photographs: painted black rods, half-moon mirrors, elongated pyramids, cones and spheres, cut-paper forms serving as light modulators. Occasionally she adds a found object, an architectural unit – a white column, part of a balustrade, a magical black object that might have been an ornate chair leg. With these she creates a mood of contemplative nostalgia not unlike that created by Giorgio di Chirico's juxtapositions of the antique with the modern.

For all her obsession with Constructivist organization of fundamental shapes, it is photography that makes the ultimate image not only effective but possible. Staged on seamless white, the constructions themselves resemble the photographs only in so far as they present the elements to the camera, much as a proscenium presents the actors to the audience. Lens and film together coalesce Kasten's optical fantasies into an artifact. *Fabricated to be photographed* is the essence of her current preoccupations, but the fabrications are as important to her as their final record on film. Deeply attracted to Constructivist theater – we recall that Moholy-Nagy was a consumate stage designer – Kasten frequently exhibits her constructions and sculptural environments to be enjoyed for their own sake. She masterminds these displays with the awesome precision of a theatrical director. Eventually she wants to work with dancers in a setting of her own invention, much as Isamu Noguchi worked with Martha Graham.

Kasten has not always been interested in photography, although she knew as a child, after she had lessons at the Art Institute of Chicago, that she wanted to be some kind of visual artist. She began as a painter, with a B.F.A. from the University of Arizona at Tucson, where her family moved when she was eighteen. Subsequently, she worked in fabric and fiber, with soft sculptures blossoming out of bentwood chairs; one humorous example trans-

formed a red chair into the ankle straps of a bulbous, open-toed shoe.

In 1968 she began graduate work at the California College of Arts and Crafts in Oakland. There she studied with Trude Guermonprez, a master weaver. Guermonprez was also a dedicated Bauhaus disciple, and Kasten had already recognized that the Bauhaus approach to artistic creation, in which experimentation with materials constituted a kind of transition from painting to architecture, matched her own interests. After teaching a semester at UCLA, her work with soft materials culminated in a Fulbright-Hays Fellowship in 1971-72; she used it to study in Poland with the fiber artist Magdalena Abakanowicz.

When she met and married Leland Rice, a California photographer and teacher, her fascination with Bauhaus photography crystallized. Together they collected outstanding Bauhaus prints, and Leland curated an exhibition of Moholy-Nagy photographs at Pomona College. Moholy-Nagy, the founder of the "New" Bauhaus – the Institute of Design in Chicago – was becoming a significant influence on Kasten, especially in his revolutionary concepts about light: it was no longer to be considered, as Moholy put it, "an auxiliary medium to indicate material existence" through chiaroscuro. "The aim is to produce pictorial space from the elemental material of optical creation, from direct light." He demonstrated the artistic potential of direct light in his many ingenious photograms – cameraless prints produced by placing various three-dimensional objects directly on light-sensitive papers.

Kasten's first experiments with photography were with photograms created with blueprints, fabrics, and finally photosensitive canvas. As she explained in a 1982 interview with Constance W. Glenn on the occasion of her *Installation/Photographs* exhibition at California State University, she constructed settings to photograph and used "4 × 5 Polaroid negatives to project geometric images." At that point she was interested in the "rigid geometric content of the work of Al Held, Sol LeWitt, Sylvia Mangold, and Dorothea Rockburne." Then her involvement in actually working with the materials, the space, and especially the illusion of space created for the camera made a

dynamic change in her approach to her work. She had never actually used a camera until she began to record her constructions using an 8 × 10 camera and Polaroid Polacolor ER Land Film Type 809. Now the camera was to become the primary factor in her thinking about her constructions.

Kasten then began to make large-format images with the Polaroid 20 × 24 camera, ultimately using the 8 × 10 as a preliminary stage for the production of Cibachrome prints. She finds the physicality of the surface of Polaroid prints "luscious," and is delighted with the kind of "etched line the layered emulsion gives you." Kasten feels Polaroid materials permit her "a working dialogue with the sculpture," adding "the color of the 20 × 24 prints is gorgeous." With her intense need for perfection of geometric form and color, she depends on the instant feedback to make adjustments in the illusionistic stage settings.

Kasten's method of working with color is probably unique. Using colored gels over tungsten lighting, she carefully arranges scrims and light modulators. She does not make multiple exposures; instead, she opens the camera shutter and then shuts off the lights in a predetermined pattern, achieving simultaneously control of the overflow of colored light and "intensity of color and balance." Each color is given different exposure lengths, with red demanding as much as ninety seconds. Over the past decade, she has acquired a formidable knowledge of the characteristics of light, pursuing research both directly and through extensive reading. She has likened her mastery of strobes, gels, and sequential exposure to the activity of painting. When she mixes light to create a specific effect, she feels that she is actually painting with light. Certainly her most recent prints are saturated with color, radiating combinations of light that are far more intense than any oil or watercolor painting could provide. The fact that most of the objects in her constructs are essentially gray makes the final result all the more exceptional and astonishing.

There are many critical issues implicit in any evaluation of Barbara Kasten's photographs. The fact that her constructions are fabricated to be photographed is at odds with a prevailing strain of purism in photographic ideology that insists only

natural realities – landscape, people, street activities – rather than imagined and conceptual realities are the appropriate subjects for the camera. One critic even went so far as to describe Kasten's images as "specifically anti-humanist in their concentration on the stagecraft of geometric form." Kasten, to the contrary, considers her abstractions to be profoundly humanistic in their play of forms.

It is true that she would seem to be following the prescription offered by Moholy-Nagy in *The New Vision,* where he claimed, "Not the representation of an object, or even of a feeling, is the real problem here, but the sovereign organization of relationships of volume of material, of mass, of shape, direction, position and light. Thus a new reality emerges." What has to be remembered is that this new reality was endowed with a Neoplatonic and Pythagorean ancestry in which the divine presence in the world is revealed through two languages of abstraction: geometry and mathematics. That number and proportion, rhythm and repetition (which have numerical analogies) are among the fundamentals of aesthetic experience has long been recognized by visual artists in all media, as well as by composers and performers. Indeed, the poet-critic Baudelaire insisted that *"All* is number . . . Ecstasy is a number!"

To counter objections to abstraction, Moholy-Nagy mocked what seemed to the moderns to be the visually exhausted tradition of narrative representationalism, saying, "The 'spiritual' factor lies no longer in the reproduction of outlines filled with 'life,' but in the effect of the relationship of elements." Like Kandinsky, who wrote passionately of the emotional effects of color as well as of the presumed psychological effects of geometric forms (and who, by the way, was as profoundly mystical and idealistic as any of his Bauhaus colleagues), Moholy-Nagy believed that art is intrinsic to human life, art is in the service of life; abstract art, arising out of the marriage of art, science, and technology in the early twentieth century, sustained and invigorated life. Abstraction, devoid of clichéd subjects reeking of literary content, was the pure path to transcendental, spiritual experience, the highest value of human life.

Kasten admits to having fought the idea that "my work might be beautiful," for beauty seemed anti-thetical to her primary purpose: to enhance perception, to open new visual avenues of exploration to the viewer. While accepting , finally, that people who enjoy her photographs might exclaim about their "beauty," she continues to view her approach to art as "research." She has by no means pursued a hermetic artistic career. Her grants include a Fulbright-Hays Fellowship, a Guggenheim Fellowship, and a National Endowment for the Arts grant for a 1980-81 project to produce videotape documentaries of senior women photographers. Her interest in video is not new, and as she is fascinated by movement as well as by stasis, she has experimented with filmmaking. Her project with women photographers – among them Florence Henri, Louise Dahl-Wolfe, and Lisette Model – involved her with questions of her own growth, an experience for which she remains grateful. With massive amounts of unedited tape waiting for the time and funding to complete the video program, Kasten remains hopeful that the finished project will help other women to grow and understand themselves as individuals as well as artists.

When I visited Barbara Kasten in her current New York studio, I was struck by the contrast between the outward environment of Canal Street on the fringes of SoHo with the studio itself. The street was visual chaos: smeared cardboard, orange peels in the gutters, worn and greasy cobblestones, cartons crammed with refuse from nearby manufacturing lofts, junk littering the sidewalks. Her studio was a haven of order: clean, neat, light, quiet. The street wallowed in urban desperation; the studio offered a welcome optimism. It was a Bauhaus kind of optimism, an approach to life that did more than suggest: it demanded reordering priorities, redesigning environments. It was an optimism some say emanates today from sunny southern California, where Barbara Kasten lived for more than a decade. Now, however, she says she wants to think about working on a larger and larger scale, in total theater, on stages where her optical fantasies can be realized in monumental form. Her intense pursuit of perfection, coupled with an ever-expanding sense of visual drama, will undoubtedly require such an ultimate display.

CONSTRUCTS

was edited by Constance Sullivan

and designed by Katy Homans.

The poems were selected by Daniel Halpern.

Production was supervised by Robert McVoy

and coordinated by Abigail Hutchinson.

This book was printed by Acme Printing Company, Medford, Massachusetts,

and bound by A. Horowitz and Sons, Fairfield, New Jersey.

The photographs are on Polaroid Polacolor ER 20 × 24 Land Film
and Polaroid Polacolor ER 8 × 10 Land Film Type 809.